chasers
of the
light

poems from
the typewriter series

—Tyler Knott Gregson—

A Perigee Book

A PERIGEE BOOK

Published by the Penguin Group

Penguin Group (USA) LLC

375 Hudson Street, New York, New York 10014

USA · Canada · UK · Ireland · Australia · New Zealand · India · South Africa · China

penguin.com

A Penguin Random House Company

CHASERS OF THE LIGHT

ISBN: 978-0-399-16973-1

First edition: September 2014

PRINTED IN THE UNITED STATES OF AMERICA

10 9 8 7 6 5

SLY

Introduction

Introductions, as I interpret them, should start at the beginning. The beginning of the story, the beginning of the journey, the beginning of the tall tale that explains how you came to be where you ended up.

This story could begin in a few different places; there's the day I wrote my first poem when I was twelve years old or the day I started writing a daily haiku. But I'm going to begin with the day I bought my first typewriter in an antique store in Helena, Montana.

I remember the way the typewriter smelled, like dust and dried ink. I remember the keys and how they stuck when I first tested them. I remember the Remington logo fading on the front. Mostly, I remember how there was still enough ink left in the original ribbon to type the very first poem in the typewriter series, the first poem in this book. I typed it in the store, standing up near the entrance, with a page from a broken book I was buying for $2.00. I typed it without thinking, without planning, and without the ability to revise anything.

I fell in love.

I loved the urgency; the particular inability to erase, edit, and alter that comes with using a typewriter; the uninterrupted stream of thoughts. I loved the way the pages reflected my mind: unfiltered and imperfect and honest. In a digital world, it felt like fresh air to hold analog words.

Over the years as a photographer and a writer, I've found a lot of ways to express inside things in an outside way, and with these poems, I've come to see that they all share a common thread. Whether the poems live on found paper, or come about through blacked-out book pages, or accompany pictures I've taken, they all try to do two things:

> Dissect big things, giant gestures, grand emotions,
> into small glimpses, tiny fragments.
> Take miniature moments, stolen seconds, blink-
> and-you'll-miss-them glances, and make them
> enormous.

The miracle in the mundane, the epic made simple.

I wrote once that I was a memory keeper, that I was a trapper of time. I wrote that I was a stealer of stolen glances, a thief of buried fears. I wrote that I was a chaser of the light. After all this time writing, and all the photos I have ever taken, I realize just how true those lines are. In all I write and all I say, I am trying to chase the light that I cannot help but see around me. This book, in the simplest terms, is a map my wandering feet have taken in that pursuit. It is simple words on random pieces of paper that snuck into my life along the way. There will always be light, and I will never stop chasing it.

What if all we have ever wanted
 isn't hiding in some
secret and faraway dream
 but inside of us now
 as we breathe one another
and find home in the way
 our arms always seem to fit
perfectly around the spaces
 between us?
What if we are the answer
 and love was the question?
What if all this time
it was us you were supposed
 to find?
I am filled with wonderings
 questions and doubt
 but of one thing I am certain:
it will always be you
 that gives flight to the
 butterflies inside me.
 calm to the sea I have become
and hope to the darkness
 all around us.
 It is you and it has always
been you...
you.
 You that soothes and excites
 and spreads joy like rainfall
on the already damp earth;
You that pulled me from the longest
sleep and kissed my tired eyelids
 awake.
 If life is a question mark,
 then you, my love,
 are the proud and bold period
 that is typed with certainty.

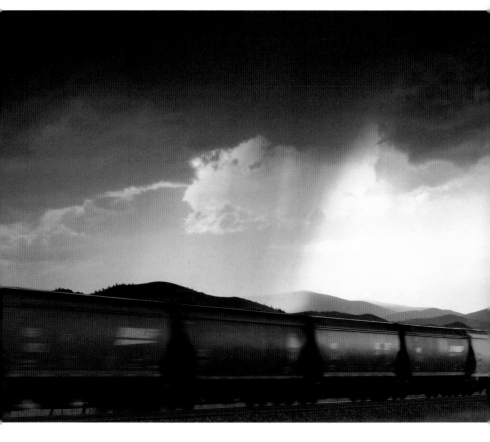

Walk with me down those old train tracks and run when we
hear the sound. Press our ears to the warm metal and guess how
long we've got until the rumble comes and shakes our insides.
Chase them, reach out your hand and jump in, and we will see
where we will go. There are times to run home and there are
times to run away and isn't it beautiful that it all depends on
where that one person is, as to which time is which? Find your
hand empty and it's home you'll run to; find it filled and away
feels even sweeter.

I Love You,
in ways
you've never been
loved,
for reasons you've never been
told,
for longer than you think you
deserved
and with more
than you will ever know existed
inside
me.

I think your applause died out,
hands red, tired, and stained
with the hue of once excited blood.
I think you thought I was magic.
Did my curtain lift when I forgot
to take my bow?
I think you thought you saw mirrors
hiding in the fog and light.
Backstage and alone
I will slide off the cape,
set down the hat,
and bow to the empty seat
I thought you were filling.
I think you thought I was magic.

for

us

THERE is only one wish

be

to

adventurous pioneers

and

find ourselves
at the end.

**Ever
Walk in
Hope,
even
though
there be
no Goal
to Reach**

79

I will miss you
always,
even in the moments
when you are right
beside me.
Time apart has planted
longing inside me
and I do not think
it is a weed
that will ever stop
growing.
It will always live there,
but my god
it grows the most
spectacular
flowers.

The words aren't falling
out of my mouth
in the same ways
anymore.
Once they felt like water,
they leaked
and rose
and baptized me new,
halo fresh without the glow.
They explode now,
confetti in a slight breeze
and I am racing around
to pick up the pieces.

Find my hand
in the darkness
and if we
cannot find
the light,
we
will always
make our
own.

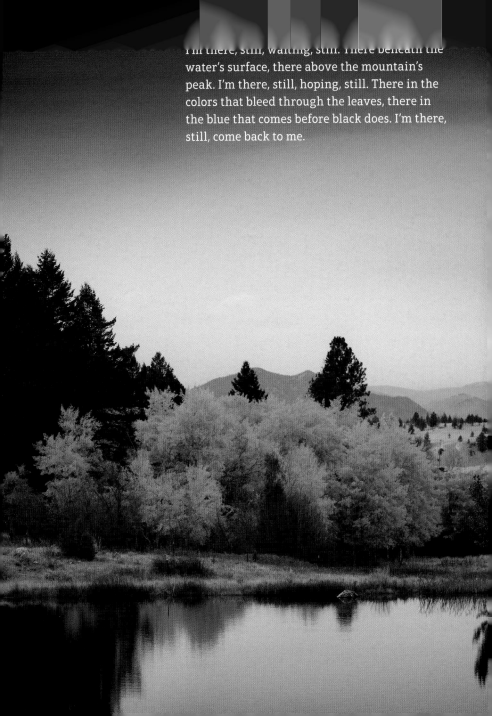

I'm there, still, waiting, still. There beneath the water's surface, there above the mountain's peak. I'm there, still, hoping, still. There in the colors that bleed through the leaves, there in the blue that comes before black does. I'm there, still, come back to me.

Peel back my skin and it won't be bones you will find.
Hiding under the muscles the tissues the scars
and the freckles are decaying timbers washed ashore.
I am a sinking ship made of unsinkable parts.
I am an old boat, built without a rudder,
a tattered sheet for a sail.
Can you see what I've been trying to show you,
that I go where the breeze decides to carry me
and you, my love, are a hurricane.

I am made from the creaking beams and rusted nails
of a lonely vessel on a lonely sea.
I am covered and coated, dusted with old salt water
and the frail residue of moonlight.
The oars and the compass, the anchor and the wheel,
have long since abandoned me.
Can you hear what I've longed to tell you,
that I go where the waves wish to deliver me
and you, my love, are the tide.

Press your ear to my chest and listen,
where a heartbeat should sing you will hear
the melancholy songs of tired whales.
The unsettled sigh and explosion of breath
as they find the surface once again.
Can you taste the salt on my lips?
Can you listen to the words I've been aching to say,
that I go where the lights pull me
and you, my love, are the stars.

Stare through the portholes of my eyes
across the grey blue and green they float upon.
Hold tight to the timbers hiding under this flesh
and fill the empty sail with your grace.
I am the fragments of a shattered ship
filled with ancient songs sung by ancient souls.
Can you feel me falling into you as you leak into me,
that I am a sinking ship made from sinking parts
and you, my love, are the sea.

Come here
and take off your clothes
and with them
every single worry
you have ever carried.
My fingertips on your back
will be the very last thing
you will feel
before sleeping
and the sound of my smile
will be the alarm clock
to your morning ears.
Come here
and take off your clothes
and with them
the weight of every yesterday
that snuck atop your shoulders
and declared them home.
My whispers will be the soundtrack
to your secret dreams
and my hand
the anchor to the life
you will open your eyes to.
Come here
and take off your clothes.

I was amazed,

your lips found
me your pulse

your eyes

leave you

for

me

Oh my heart, how you flee from me to rest in other homes, to beat softly in other chests. Have we lived if we have never been loved unconditionally, can we die once we have, or is immortality there, in the constant love we receive long after our breath is no more?

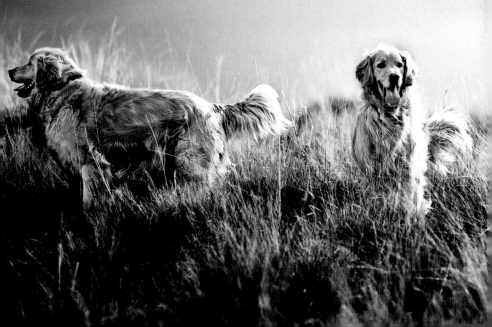

Richard M. Flemming

Find the positivity. Find the grace. Find it
and hold it and cling to it like it is your
lifeline and only breath of air before
everything sinks. Find the silver linings.
Hold them in your lungs and search for them in
the bubbles and rubble of all that pours down
around you. Find the bright spot in the dark
clouds, listen for the sounds of the birds when
the winds pick up and tear down the house around
you. It is there, shhh, it is there, it is always
there and it is waiting for you to reach out
with both hands, bloody and shaking, and hold
tight to it like it is the last thing you will
ever learn how to let go. Find the glory, the glory
through the ache, and understand that it is what
we can endure that defines who we become. That
it has never been about the punches we can throw,
but the punches we can absorb and still stand
up from. It is the standing up, it has always
been the standing up and the refusal to lie still
and quiet as the numbers count towards ten and
the knockout becomes complete.

Rise my soul, rise through the flame and the ash,
rise through the waters that fill the spaces
under your arms as they crawl toward your throat.
Rise and find the grace, for it is all around you.

Find it. Find the grace.

Amazing
how manageable
life
can feel
with only
one blanket
and the right
two arms.

When my arms
wrap around you
can you feel
my fingers
clinging
to the fabric
of your clothes?
"You hug me
like I might blow
away,"
you whispered,
but all the fabric
wrapped in all my
fingers was not to
keep you here,
but to go with you
when you did.

spoken we with no word

 lay down and

amends for a lack of made

 us

We
are the only
people I have ever
known
that can
make love
from across
a
crowded
room.

We are made of passion. We are
made of the half-lid glance out
of the eyes glazed over. We are
the long sigh when the weight of
one rests on the chest of the other
after the exhaustion of intimacy
collapses arms. We are the foreheads
slowly touching and the shaking
arms cradling and the quiet reach
of a strong hand to bring lips
closer and kisses deeper and
whispers sweeter. We are the
emotion that has never fit inside
either of us and never will.
We are the crumpled sheets and
pillows fallen to the floor.
The hair disheveled and the out-
paced breath and the quivering
skin that follows.
We are the passion.

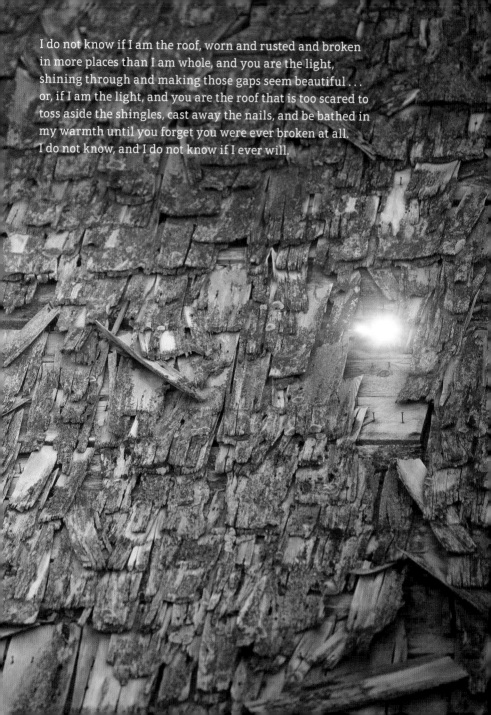

I do not know if I am the roof, worn and rusted and broken
in more places than I am whole, and you are the light,
shining through and making those gaps seem beautiful . . .
or, if I am the light, and you are the roof that is too scared to
toss aside the shingles, cast away the nails, and be bathed in
my warmth until you forget you were ever broken at all.
I do not know, and I do not know if I ever will.

You have never
had to steal
my breath
or take it away,
somehow
you have always
managed to convince me
to hand it over
freely.

Sometimes you look up and there just seems
to be so many more stars than ever before.
More. They burn brighter and they shine
longer and they never vanish into your
periphery when you turn your head. It's as if
they come out for us and to remind us that
their light took so longto come to us, that
if we never had the patience to wait, we
never would have seen them here, tonight,
like this.

That as much as it hurts, sometimes it's
all you can do, wait, endure and keep
shining, knowing that eventually, your light
will reach where it is supposed to reach
and shine for who it is supposed to shine
for.

It is never easy, but it is always worth it.

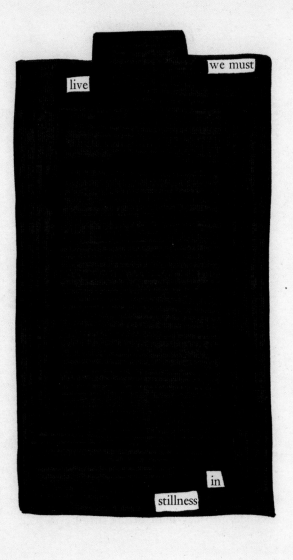

live we must

in
stillness

Maybe if I
were instead
a baby bird,
you wouldn't always
have to come up
with excuses
for holding me,
soft and tender
in your hands.
Maybe if I
were instead
a baby bird,
I wouldn't always
have to come up
with excuses
for not flying away
from here.

She rolled over,
buried half her face
in her pillow,
and smiled
slightly.
It was then,
the overwhelming
realization
washed over me,
that there is
so much more
to life
than simply
surviving it.

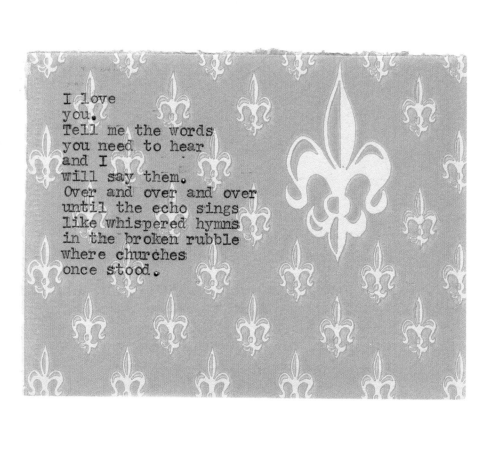

I love
you.
Tell me the words
you need to hear
and I
will say them.
Over and over and over
until the echo sings
like whispered hymns
in the broken rubble
where churches
once stood.

Will you follow me down that old dirt road and get lost inside those mountains? Will you rip up that map and dance inside the confetti? Let's chase the horizon and find ourselves along the way. These are wandering feet and they wish for yours to join them.

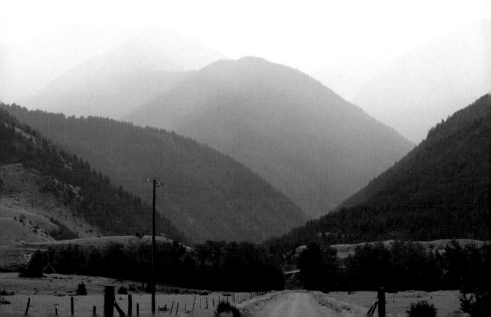

What good
is a half-lit
life?
You
can burn me
to ashes
as long as I know
we lived a life
alight.

JE T'AIME

Your lips come to rest
gently atop mine
and I feel the words
I Love You
simmering beneath their surface.
You speak them
and touching as they are,
my lips like marionettes
are moved in time
with each syllable.
Your declaration
becomes my proclamation
without me ever
having uttered
a sound.

we must

never
while

forget

we sit wavering

of

courage,

to

have hope

Sometimes
the only way
to catch
your breath
is to
lose it
completely.

I want to hear your breath,
the slow and steady rhythm
and rise and fall
and fall and rise
as it rocks me to sleep
and I want to see your eyes
open one at a time
to the brightness
of new mornings.
I want to know what your skin
feels like after three days
of traveling and no bother
of a shower because what
we see is more and worth
more than how we feel.
I want to hold your hand
and feel the squeeze when you
are absolutely terrified.
I want to see you smile
when you are worn out from
making love to me and I want
to carry your limp arms
into the shower to let
the warmth soothe us
back to life.

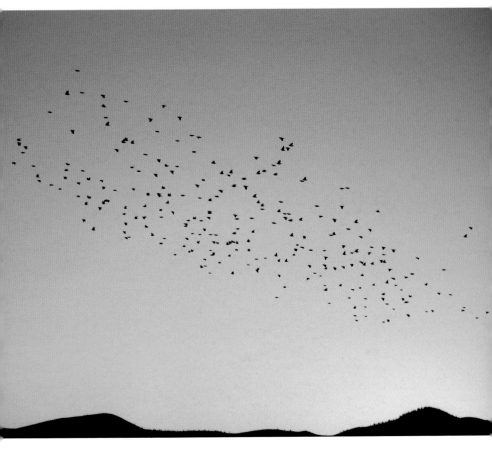

And if light shall fade
and fall to black,
let the sound of wing beats sing,
that you're coming back.
And if dark shall stain
and ink your wings,
follow my whispers,
to far off things.

XXVI

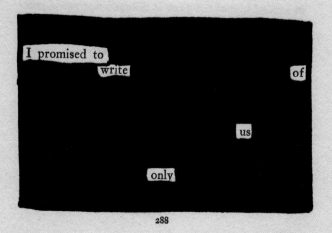

I promised to write of us only

288

What should I say
when I want to kiss
the side of your neck
and leave it at that?
When I want to feel the heat
of my own breath bounce back
and warm my lips after I
strategically place them
on my favorite pieces
of your skin.
I want to leave goosebumps
everywhere I have not yet
kissed and spend the night
trying to read them
like Braille.

Now I Lay Me Down to Sleep . . .

Be gentle,
always delicate
with every soul
you meet,
for every single morning
you wake up,
there is someone
Wishing,
silently
and secretly,
that they
had not.

I am haunted
by the things I miss
and the times my name
doesn't fill your mouth.

I need a word
for the way that feels,
for all the combinations
of all the letters
dont seem to say it
properly.

I count the syllables
of your laughter
and wait
for the line breaks
of your long deep breaths.
I may be a writer
but you are a poem
and you spill out
like ink
onto the paper
of our days.

Maybe I
was born
with you
inside me.
Maybe I
have always
carried you
with me.
Maybe you
are all
the wild
in me.

Promise me
you will not spend
so much time
treading water
and trying to keep your
head above the waves
that you forget,
truly forget,
how much you have always
loved
to swim.

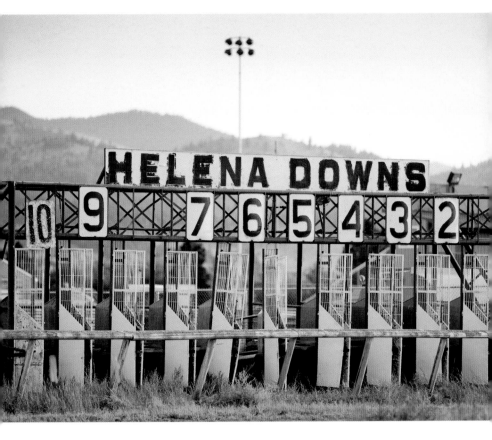

8 loved his slender frame and prominent nose. She loved how he always stood up tall and never slouched and was never afraid to lead the way for the rest. **1** loved her for her curves and the bravery that came in embracing the shape she was born with. He loved the way she didn't care what the others thought and always felt like a smile. They left the Helena Downs together, bold in the leap where the others stuck and settled. They'd all heard the rumor of the last time someone left, the legend of **10** and how he too took a chance, but finally found his way back, never feeling quite the same, never having the same sparkle or shine. Still they went. **1** and **8** and they've not been seen since.

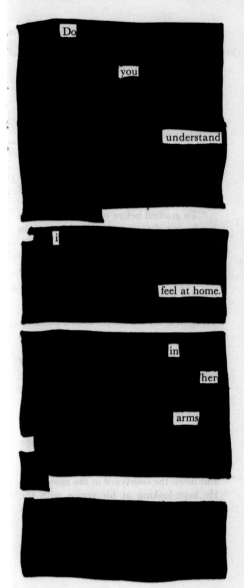

Do

you

understand

i

feel at home.

in

her

arms

91

Should I,
this I
nearly asleep
before you,
take pride
in the fact
that I,
this I,
quiet hands
and waiting lips,
know you,
this you
decorating the bed
with your skin,
and all the spots
that make you
shiver?

Look up more than down. See more than say. Listen more than speak. Hope more than dread. Believe more than criticize. Yes more than no. No more than maybe. Laugh more than cry. Love more than hate. See. More. See.

I want kisses without question marks
and if at some point one lingers
I want the passion we share
to make those marks stand at attention,
straighten their backs
and transform themselves back
into the exclamation marks
that used to and always should
lock themselves to our lips.

Can't you see
from where you
sit
that I have scars
to kiss?
Can't you hear
from where you
rest
that I just may be
crazy?
Can't you feel
from where you
sleep
that it's always
You
that I
miss?

if you are quiet

I

wait until

you

Tell me

Tell me what you

dream

of

I do not need the photos,
and the taste of envelope glue
does not need to dance atop my tongue.
I will never need the unsaid words,
or the ink stains from unwritten letters,
or the bits of clothing left loose,
crumpled and soundless
beneath the bottom of the sheets.
I will keep you here, always here,
where the nameless things sleep sound.
I will keep you here, hidden here,
as a familiar sensation on the tips
of long untouched fingers,
the abandoned hallways begging
for a ghost, and the smell I cannot place
but has never forgotten me.

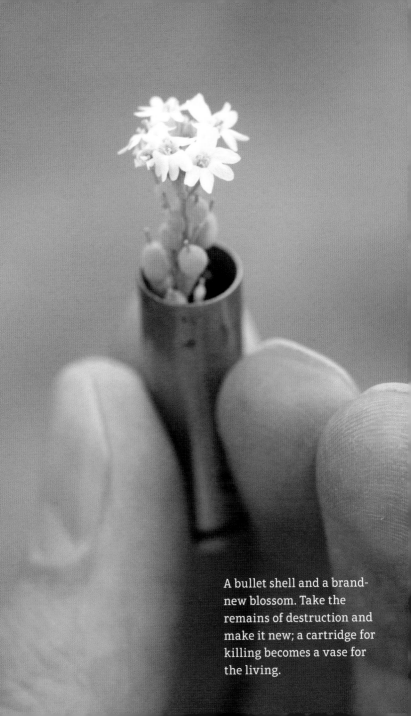

A bullet shell and a brand-new blossom. Take the remains of destruction and make it new; a cartridge for killing becomes a vase for the living.

You should know this,
that I love you
that I have always
loved you
and nothing,
no force in this
universe,
can stop me
from loving you
still.

THE END

F - B66ro

When we
are we
and a closet
we share,
I
will hang my clothes
in the opposite direction
as yours,
because after a wait
like this,
I think even they
deserve to always
be walking
directly towards
each other.

I am
desolate

a

wanderer

with

feet worn out

all this while I
went alone

If I died tonight
I think I
would like to come back
as your morning
coffee.
Just as strong
and just
as necessary.

-Tyler Knott Gregson-

My arms aren't quite long enough
to wrap all around myself,
and I have discovered
that interlocked fingers
on the small part of the spine
make all the difference
in the world.

I promise you
I will try harder
to be better.
I
have battled with things
inside me
for longer than you know;
I do not know
what they are
or why they are there,
I only know
that they feel
managable,
defeatable,
when I
am around
You.

I

Miss

you

so

much

Weary hands and heavy hearts be still.
Swollen eyes and stolen breath be still.
Shaking skin and soul-sick sighs be still.
Unheld glances and untouched fingers be still.
Be still.

You were the sound of wandering feet
and rainfall in the trees.
We thought,
god, we always thought
there would be enough
time.
I was the moss
that held the imprint of your shoe,
and I loved my indentions.

I was nothing,
but you found me.

You were everything
and I hold proud
the marks you made.

You
are the poem
I never knew
how to write
and this life
is the story
I have always
wanted
to tell.

What if it's the there
and not the here
that I long for?
The wander
and not the wait,
the magic
in the lost feet
stumbling down
the faraway street
and the way the moon
never hangs
quite the same.

And no matter the room
or the furniture between us,
I will brush your hair
back behind your ears
with my eyes
and I will kiss
the sides of your neck
with a glance.
I will unwind the fabric
and uncover the skin
and decorate it all
with goosebumps.
Then, I will blink,
find your eyes,
and realize I never
even left my chair
for a single
moment.

I am so tired
of waking
to the blank canvas
of morning
and realizing
it won't be
painted
with you.

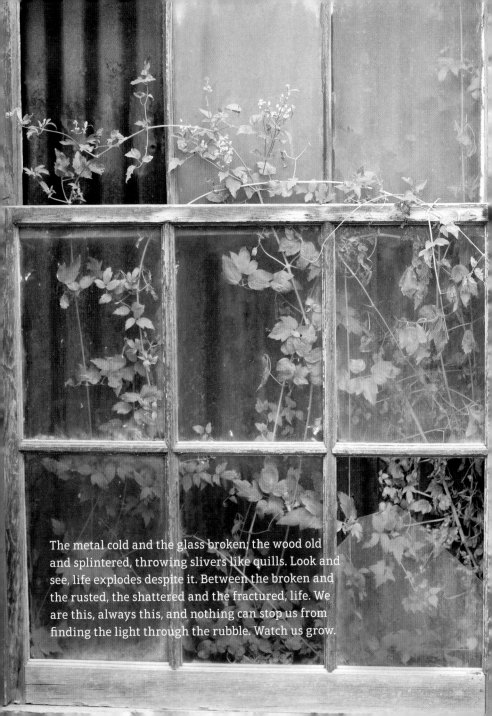

The metal cold and the glass broken; the wood old and splintered, throwing slivers like quills. Look and see, life explodes despite it. Between the broken and the rusted, the shattered and the fractured, life. We are this, always this, and nothing can stop us from finding the light through the rubble. Watch us grow.

a=3

It was when I
with fingers
like wands,
curled your lips
into a
smile,
that I hoped
you
realized that
I,
and only I
will be the
orchestrator
of the greatest
happiness
your life
will ever
know.

CHAPTER II

PURE AIR AND THINGS THAT SPOIL IT

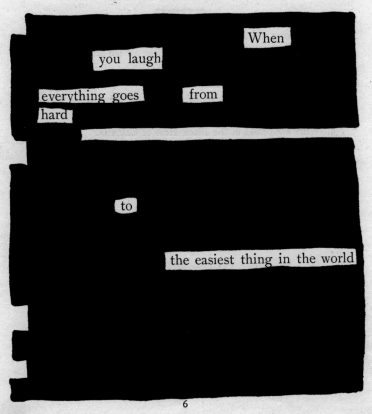

When
you laugh
everything goes from
hard

to

the easiest thing in the world

Some days in this life, you are the tracks that lead off to some mysterious and wonderful distance. Some days you are the train, strong and filled with purpose and fire and the promise of a destination. Some days, my friends, you will be the coins, and on those days, when the weight of the world is about to run you over and the tracks feel like they are frozen and silent, just remember . . . soon, someone will run to the tracks, ignore the distance they lead to, forget the sound of the train that passed, and search frantically for your transformed self, shining and smooth. They will pick you up, they will hold you forever and when age catches up to them, it won't be the train or the tracks they will remember, it will be you, the coin.

Place your hands upon me
like a big tent preacher
and with a whisper
heal all that aches
inside.
Put your lips upon my forehead
and glance your eyes
to the sky,
tell me that I'll walk again
and tell me
I can fly.
Hold me like a revival
and shake the demons
from my skin,
touch me like a fever
and kiss me
like a sin.

How quickly jealous
I become
of the wind
when it,
and not I,
gets the privilege
of properly
messing up
your hair.

I will live. More. So much love that no
one will have any idea what to do with me.
They will watch with a confused look and
wonder why I give so much and do not ask
for more in return. I will give it because
giving is getting and there is nothing
quite so important as emptying your heart
every single day and leaving nothing
undone, no declarations of it unsaid.

I will not only stop and smell the flowers,
I will plant them myself and watch them
grow old with me. I will pull over and
dance in every single rainfall, and I
will make snow angels even when there is
hardly any snow left for the wings.

I will never, ever believe in the words
"too late" because it is never too late
to be exactly who you wish, do exactly
what you should, say exactly what needs
to be heard, and live the exact life
you should be living.

I would love to say
that you
make me
weak in the knees,
but
to be quite upfront
and completely
truthful,
you
make my body forget
it has knees
at all.

Run. For your life, for your joy, for your calm and peace of mind. Run. Because your legs are strong and your lungs are aching for the taste of air. Run. Because what's the point of a life spent walking in the middle?

I

only ask

for

passion and

her
tender

ecstasy

I want us. I want to swim in the
way you make me feel; I want it
to soak my clothes until they
become a skin, and I want that
skin to soak into my bones. I
want to become the way it feels
in the instant you stare at me
from across this crowded place.

If it's pieces of me
you find lying scattered
across the floor
under your feet,
please do not stare and wet them
with the regret-filled water
living in your eyes.
If cracks you find,
please, please,
tell me they are scratches
and never breaks,
handsome lines on weathered skin.
Don't ever tell me I'm broken
if you will not
be the glue,
and please
don't point out the fractures
if that's all
you're allowed to do.

I pressed my ear to your chest
and heard the ocean beneath your skin;
tell me that the water's warm
and I will follow you back in.

Tell me you're a mermaid
and I'll walk into the sea;
I'll let the waves rise up
I'll let them bury me.

You giggle,
softly,
and the sound of laughter
leaping
from your lungs
slows me to a crawl.
That laugh,
my god, that laugh
refills all that spilled
from me;
it is the
oxygen mask
to the plane crash
I have always
been.

Was there always
this much night,
and didn't the moon
used to flirt
with me
from time to time?
How do I cross this
divide
and will I ever know
where you're hiding?
I am reaching
with fingers
stretched.

Part those sheets
like holy waters
and I
will worship your skin
like a born-again
believer.

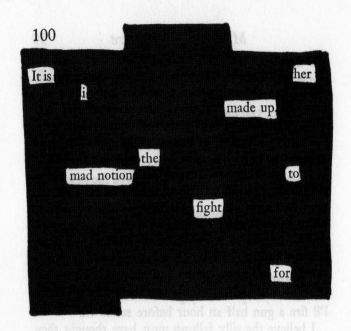

100

It is
i
her
made up.
the
mad notion
to
fight
for

I
am
too little
butter
on too much –
bread,
I
am
too many
thoughts
in too little
head.

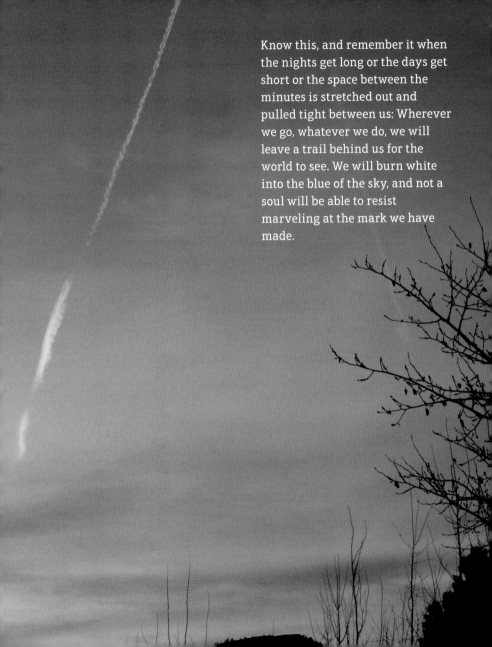

Know this, and remember it when the nights get long or the days get short or the space between the minutes is stretched out and pulled tight between us: Wherever we go, whatever we do, we will leave a trail behind us for the world to see. We will burn white into the blue of the sky, and not a soul will be able to resist marveling at the mark we have made.

Hold

our

life

Without any

fear

I love you
with every
piece of me.
I will love
and love
and love
until I have nothing
left,
and then
I will make more
out of the nothing
that lives
where everything
once did.
I would
dismantle me
to put you
back together
again.

I overheard the man
whisper,
"I am a lover
not a fighter,"
and to myself
I thought,
I
am in fact
both.
For is it love
at all
if it's not worth
fighting
for?

"Thank You"
she whispered soft
like it may
blow away
with anything stronger
than a breath,
"for fixing me."
"You,"
I sputtered out
like the first sound
of morning,
"were never
broken."

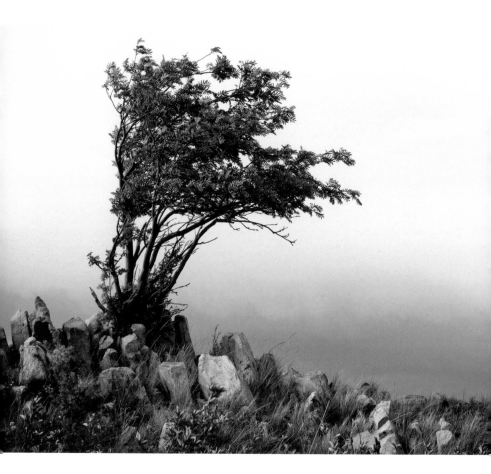

The storms will come and the winds will rise and the gusts will threaten to pull you from your roots. Let the winds come. Let them rage and know that you will not break in the breeze, you will bend. Bend. Always bend because you are made of more strength than you know, because you are better than the breaking.

Come now the
flood
for you
have no idea
how long
I
can hold my breath.

Do you think it possible
that some people
are born to give
more love
than they will ever
get back
in return?

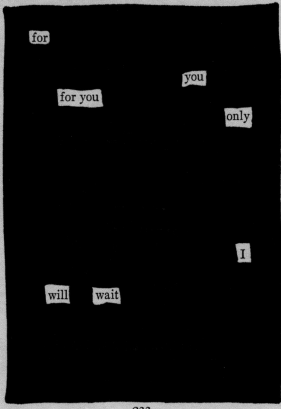

233

I promise to
plant
kisses
like seeds
on your
body,
so in time
you
can grow to love
yourself
as
I
love you.

We
are the lonely remnants
of scattered dreams.
The phantom hands
rubbing forgotten backs
and the flashes
of eyes through the night.
Smiling or laughing
red with tears
hanging from the lids.
Too heavy to stay
too scared to jump.

We
are the missing pieces
of broken pictures.
There is not enough air
and I've not enough lungs
to hold the sigh
that relieves.
The absent fingers
tracing invisible lines
around swollen eyes
and stained cheeks.

We
are the staccato images
of lives not lived.
Swimming through our sleep
like broken slideshows
and skipping records.
The tired glances across
empty rooms
the shared breaths
through the choking silence.

We
are the stolen hope
of diverging paths.
The hair tangled in the hands
the slow closing
of soaked eyes
and the burying of our faces.
The distance between our bodies
as it grows wider.

Please
grab hold
of my neck
and whisper
sternly
into my ear
that you
did not forget
to remember
me.
You did not forget
the way I warm you up,
the pace
of our love.
The way my heart is tender
or how hard you laugh?
The way I smell
or how my arms
hold you
like they were made
out of the empty space
that surrounds
you?

Right now
I smell
like old
books.
My hands
scented
with tired
words
and broken
ideas.
Right now
I smell
like paragraphs
and one too many
adjectives.

If I am a wave
 then you
are the sea.
If you are a flower
 then I
am your bee.

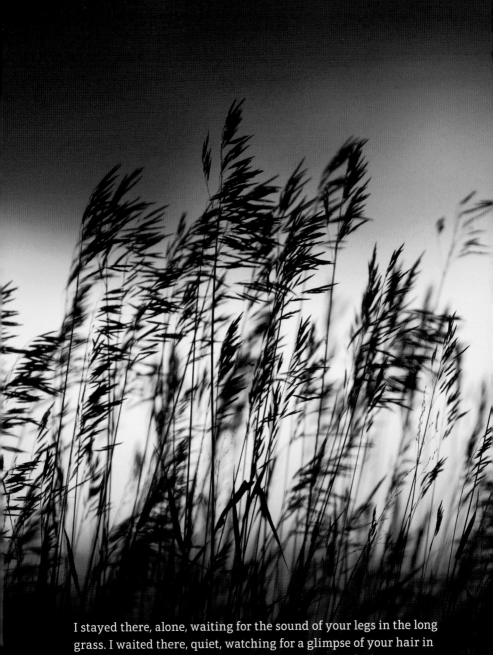

I stayed there, alone, waiting for the sound of your legs in the long grass. I waited there, quiet, watching for a glimpse of your hair in the wind. I am there still, tired, believing you will find me.

Shall we sleep,
my love?
Fall into the hazy
palm of it
and feel its long fingers
wrap around our flesh?
Shall we take note
of the shallow indentations
its grip leaves behind
on our skin?
Shall we sleep,
my love?
Become the quiet sound
in our ears
of our heartbeat against the pillow?
Feel our breath
leave our lungs and imagine it
stirring together and dancing
above our heads?
Shall we sleep,
my love?
Trade all the light
and fury of this
for all the color and calm
of that?
Curl together and watch
as our legs become roots
that grow down from this bed
and plant themselves
into the earth below?
Intertwine.
Shall we sleep,
my love?

it is not solitude that

separates me

from you It is the

lost

touch

with

shaking hands

the wild

between us wandering

far

from

home

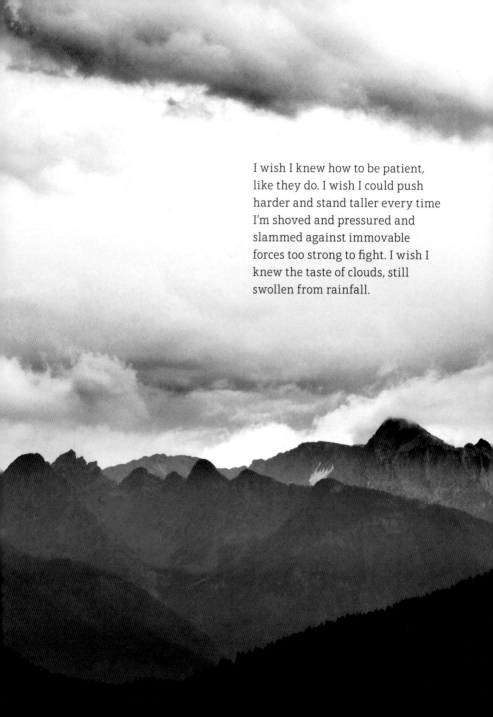

I wish I knew how to be patient,
like they do. I wish I could push
harder and stand taller every time
I'm shoved and pressured and
slammed against immovable
forces too strong to fight. I wish I
knew the taste of clouds, still
swollen from rainfall.

If I chase
your echoes
down the hallways
long enough,
if I just
get ahold of them
once,
just once,
will it bring you
back
to me
again?

in

hope is

strength

embrace it and find

me

I, I have discovered, am an unsortable sort
of man. I open my mind to the pages before me
and the words fall out. They drip
like extra paint onto extra walls
or blood too rebellious to stay inside the confines
of racing veins.
I, I have discovered, am the sort of man that must write,
to keep locked tight the breath in his lungs.
Every word has a soul inside me, a body and a life
and don't they all deserve a chance at living it?
How can I stop now and leave widows of words
as those they found love with were destroyed by
and buried beneath the bombs of my apathy?
I, I have discovered, am the exact sort of man
that fixes, or tries, the broken around him. I pick up
the pieces, whatever those pieces may be and wherever they
have fallen from, and try to find the picture they once made.
I am the painstaking and careful tying of a popsicle stick
to the broken wing of a broken bird.
I am the breathless wonder, whether or not
she ever finds flight again.
I, I have discovered, am the sort of man who cannot help
but believe. In myself, in every single body else, in something
bigger than all of this, in hope and promise and the
unstylish and embarrassing dream that we can still be
exactly who we have always wanted to be.
I, I have discovered, am an unsortable sort of man.
If it is filing and sorting and finding order
in the orderless that suits you,
when you come upon me to file, I offer now
my most sincere apologies.

I turn
(and
when I
turn the
whole world
stops
spinning)
to tell
(and
when I
open
my mouth
the words
fall out
like rain)
I
Love
(and
when I
say Love
I mean
more
than
anyone
has ever
loved
any thing)
You
(and
when I
say
You
the rain
stops
and I
mean
only
You)
.

This kiss
and that kiss
on this piece
and that piece.
I am all
lips
and you
cannot help but
be
a perfect
pile of pieces.

Oh what we
could be if we
stopped carrying
the remains
of who we were.

I might be lost at sea
but that will never mean
that I do not tilt my head
back, stare up at the stars
and sacrifice the salt in my
tears like an offering of my
most sincere and honest
gratitude for the way the water
never seems to stop rocking me
back to sleep.

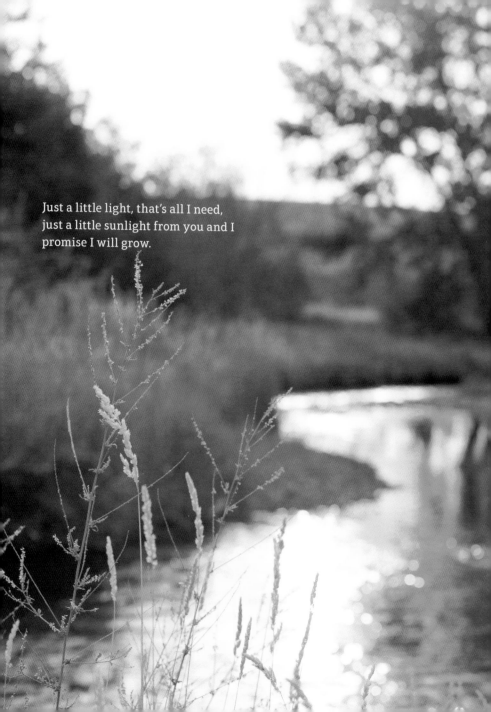

Just a little light, that's all I need,
just a little sunlight from you and I
promise I will grow.

My ear stays pressed
against the ground
in all the places your feet
found rest.
I track the echo of you,
ghost steps on haunted floors,
and I wait forever
for the sound of footsteps
that might never walk back
to me again.

Dizzy
from the pace
of us,
did you hear me
whisper
"That
is how love
is made"?

this constant tangle of
fragments of

her feel

indispensable To
me

I am Midas.
I am Midas,
I should say,
in that all I touch
will wish and wish
that their skin
never bore the tattoo
of my fingerprint.
I am Midas.
I am Midas,
I should say,
except for I
can't even for a moment
before the ruin
see myself
in the gold.

I do not know
if I
will ever be
complete,
but I know
whatever I am,
You
will always be
the rest of
me.

She juggles fire
every single day,
forces a smile,
and laughs
at the burns.
I will never stop
kissing the scars
that remain.

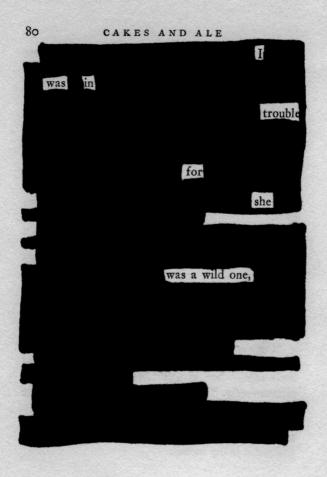

I

was in

trouble

for

she

was a wild one,

She walked past like it was nothing,
like she had walking feet
and I had staring eyes
and her scent followed behind.
It stayed when she left,
it found a way to stick to me.
She smelled like 5 a.m.
when it is far enough into the year
for light to play that early.
She smelled like rain that came
when the sun stayed out,
and for a moment it felt like
Mother Nature tripped
and spilled a bag of diamonds.
She smelled like home,
but the kind that is made
not bought, with memories
plastered like wall paper,
and still filled with the ghost
of whoever I was
before she walked past.

An ocean
of
difference
exists between
making love
and
being made
by it.

I
have blisters
on my
feet
from dancing
alone
with your
ghost.

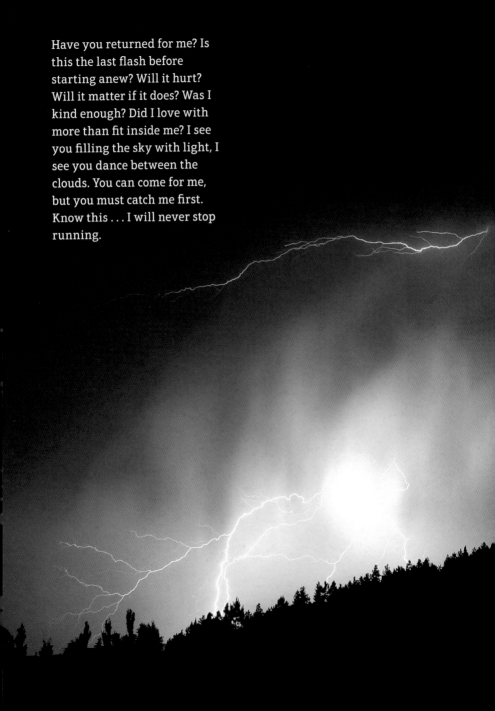

Have you returned for me? Is this the last flash before starting anew? Will it hurt? Will it matter if it does? Was I kind enough? Did I love with more than fit inside me? I see you filling the sky with light, I see you dance between the clouds. You can come for me, but you must catch me first. Know this . . . I will never stop running.

Through Golden Windows

We

are

the

poetry

living

in

us

The black inside the color,
the dark hollow of your eyes
widens, slow, like an eclipse
to the light inside you.
If I were an ancient one,
I would fall to my knees
to worship the power
of the darkness you summon.
The breath, the soft rattle
that keeps you dancing
through your days,
abandons the ship of your lungs
and dives head first,
swimming on the skin
of my neck.
If I were a salt-stained sailor
I would jump to the sea
and smile calmly
as we sank together.

The shadow of my face
crawled slowly across
yours
as I leaned from side
to side
to kiss
your unkissed bits.
Maybe I
have always orbited
around you.

"What do you want for dinner?"
I voiced into the echoing part
of the kitchen,
and as the R syllable
bravely dove off my lips
I realized
that there would not be anyone
to catch him.

I kiss you
and
on your lips
I taste the
sea
and the
sea
has always been
home
to me.

I remember

us

beautiful

Success
out of
Failure

and

exhaustless

we loved

both hands

full of

life

we loved

129

A moment,
a smile;
a single burst
of laughter
that sounds exactly like
the rest
of my life.

We stand shivering at the door,
terrified and panicked
that we have lost the key.
We waste lifetimes
in the waiting
because in the haze,
the painted fog
of our fear,
we forget
to check the handle
and discover
it has never been locked
at all.

-Tyler Knott Gregson-

I might spill myself

All

of

me

drain out

leak.

be

afraid of

losing

me.

We are all
looking
for the right
reasons
to want to
get out of
bed
each and
every
bitter cold
morning.

Speak to me with morning voices
and glance across that pillow
with dawn in your eyes.
I want to hear you stir from sleep
and listen to the sheets
as they whisper of your rising.
What worth does this day hold,
if it does not begin
with you?

They look like letters,
they always have,
ink black and curled
with the rules
of alphabets.
They look like letters
but they are
and always have been
fingerprints
I left behind,
the fog on the glass
that remained
from where I stood
when I watched
you leave.

Flowers grew where you stood,
sprung from the soles of you,
strong despite the shade
from the shadow you left.
You leave gardens
every time
you walk away.

we had

a glimpse into

a perfect

life—

We wake

to the sound

of wind through trees

Too much
me
too little
you.

Take it all away,
tear it and scatter yourself
into the breeze around me
and haunt me
with the pieces I cannot catch.
Hear me,
as you shred yourself
like confetti
that never found its
celebration,
hear me:
I
would love the scraps
of you.

Oh my soul, find peace in the stillness. In the dark silhouette of tree on sky, mountain on the fire in the clouds, find the calm you are choking for. Listen now, slow the beat and listen, all things will find their way to you, all things will settle and the lacks will flood over once more. Have no fear, for you have passed through the darkness and carry the stains of color and residue of light from before it surrounded you.

 If only I could show you
the stuffing that stretches our seams,
the fluff that fills our empty bits,
and the space between our spaces.
 If I could pull it all out
long and connected like magician's scarves
hidden in magician's sleeves,
I would show it to you with great fanfare
and with imaginary sweat dripping down
my forehead from the imaginary spotlight,
I would take one long deep and lasting bow,
for the truth would be spilled out in front of you.
 Dangling from my hands, but the illusion,
the secret and the style behind the substance
would bring hands together in unison and in
uproarious applause.
 All the threads that tied together made us up,
the spools born into us, unwinding, and the extra
we added along the way; carried, saved,
like we were bird beaks and our hearts, a nest.
When held out for you, arm's length and decorated
with colored lights from the aging stage,
creaking floors and tattered seats,
here is what you would find, what we are made of
after all this time:

We are the memory keepers and the trappers of time;
stealers of stolen glances and breathless lungs
from all that have been taken away. We are the
noticers of subtle signs hidden in plain sight by a
benevolent universe bigger than we'd ever believe.
We are the thieves of buried fears and the confidence
left behind, left like jingling coins under sleeping
pillows after first teeth have been carried off.
We are the leapers and the builders of wings on the fall
towards the ground. We are the wingbeats and the sound
of flying. We are the directionless wanderers and the
destinationless travelers and we are the crumpled map
that never got packed to join us. We are the cinematic
lovers and the translucent curtains saturated in light.
The soundtrack to the moments without sounds and the
swiftness that two bodies can become one in the stillness
of a second. We, says the last string pulled out, the
final string that kept it all together, balled up tight,
filling us after all this time, We, are the chasers
of the light.

About the Author

Tyler Knott Gregson is a poet, author, professional photographer, and artist who lives in the mountains of Helena, Montana, with his two golden retrievers, Calvin and Hobbes. A graduate of the University of Montana's liberal arts program with a bachelor's degree in sociology and criminology, he focused on psychology and religious studies, which included Eastern philosophies, Native American spiritualities, and alternative belief systems.

When he is not writing, Tyler Knott owns and operates his photography company, Treehouse Photography, with his amazingly talented partner, Sarah Linden. They photograph weddings all over the world, and just like his writing, believe in capturing the silent moments, the hidden glances. Big things made small, small things made big.

Tyler Knott has been writing since he was twelve years old, and after finding Buddhism that same year, started seeing life in

a different way. With wide-eyed fascination and a Whitman-esque appreciation of nature, life, and the miracles in the mundane, he began writing at a young age about everything he experienced. Love, the dynamics of emotion, and the physical connections between people have always bubbled to the surface of his writing.

tylerknott.com
treehousephotography.org
Instagram: @TylerKnott
Twitter: @TylerKnott
Pinterest: pinterest.com/TylerKnott